Painting Angels
in
Watercolour

ELAINE HAMER

SEARCH PRESS

First published in paperback in Great Britain 2008

Search Press Limited
Wellwood, North Farm Road,
Tunbridge Wells, Kent TN2 3DR

Reprinted 2010

First published in hardback by Search Press Ltd 2007

Text copyright © Elaine Hamer 2007

Photographs by Roddy Paine Photographic Studios, except for
the materials shot on page 6, by Storm Studios.

Photographs and design copyright © Search Press Ltd. 2007

ISBN: 978-1-84448-396-9

The Publishers and author can accept no responsibility for
any consequences arising from the information, advice or
instructions given in this publication.

The Publishers would like to thank Winsor & Newton for
supplying some of the materials used in this book.

Suppliers
If you have difficulty in obtaining any of the materials or
equipment mentioned in this book, then please visit the Search
Press website for details of suppliers: www.searchpress.com

Publisher's note
All the step-by-step photographs in this book feature the
author, Elaine Hamer, demonstrating her watercolour painting
techniques. No models have been used.

There are references to animal hair brushes in this book. It
is the Publisher's custom to recommend synthetic materials
as substitutes for animal products wherever possible. There
is now a large range of brushes available made from artificial
fibres, and they are satisfactory substitutes for those made
from natural fibres.

Printed in Malaysia by Times Offset (M) Sdn Bhd

Acknowledgements
*Many thanks to my husband Brian
for his absolute and loving support.*

Dedication
*This book is for my son and
daughter, James and Lucy.*

Cover:
Morning Angel
*This painting involves most of the techniques mentioned in
the book. Stronger colours have been used to contrast the
light of the angel with her background.*

*This is achieved by mixing up a stronger wash and building
up the layers, allowing them to dry in between each wash
until you have the desired effect. This gives a more dramatic
result to the finished piece.*

Page 1:
Starlight Angel
*A combination of gouache and watercolour paints have
been used to create a warm golden aura for this angel.
Varying the strength of the gold, yellow and ochre washes
gives a depth of tone, shade and light to create a subtle
three-dimensional effect. White gouache has been used to
detail each feather.*

Opposite
Loving Words
*A slightly different technique has been used here. The use of
a fine waterproof ink pen has outlined the angel. Soft golden
watercolour hues bring the angel to life and lift what would
otherwise have been a flat, two-dimensional image.*

Contents

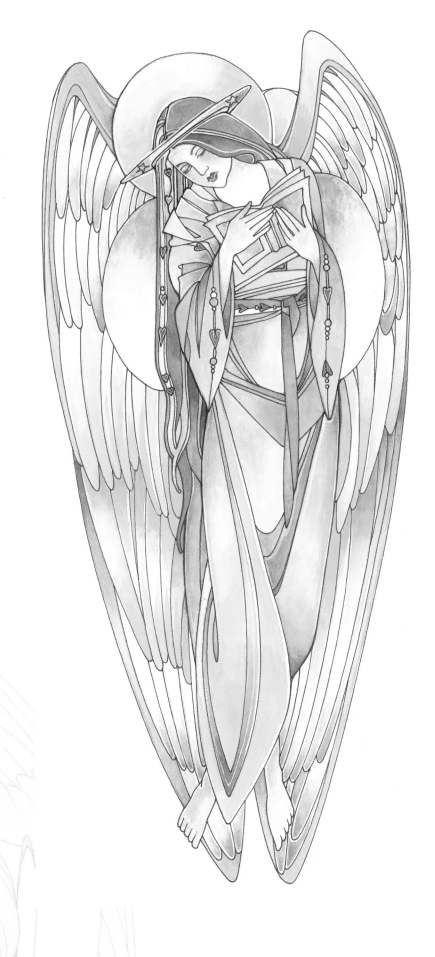

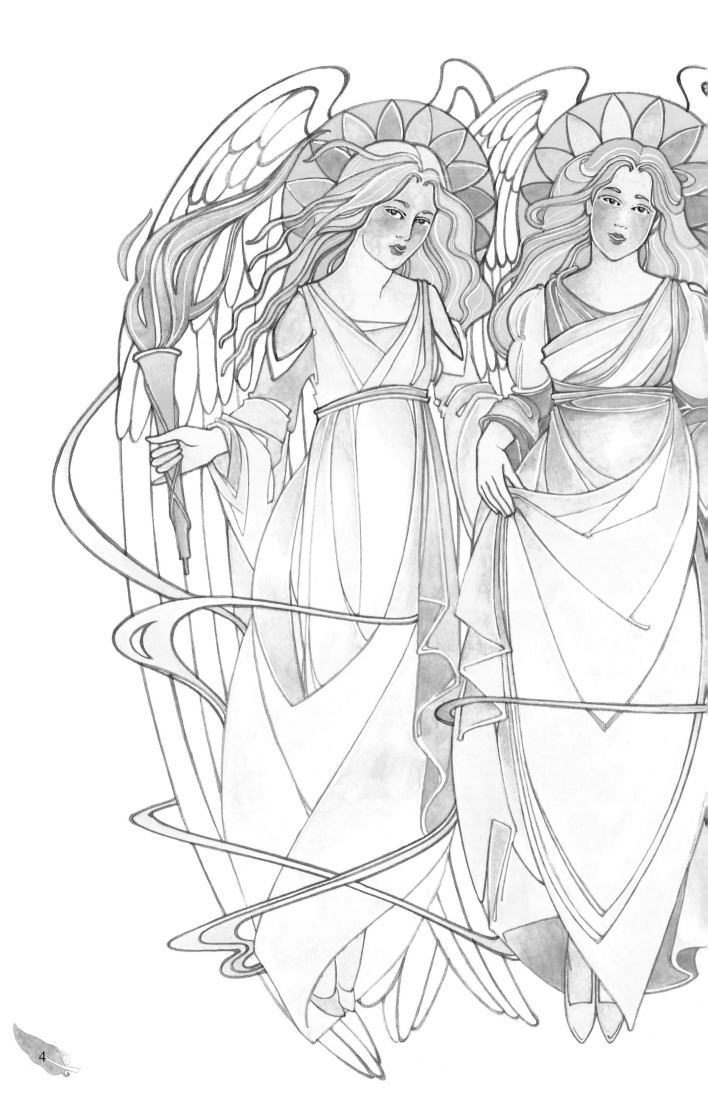

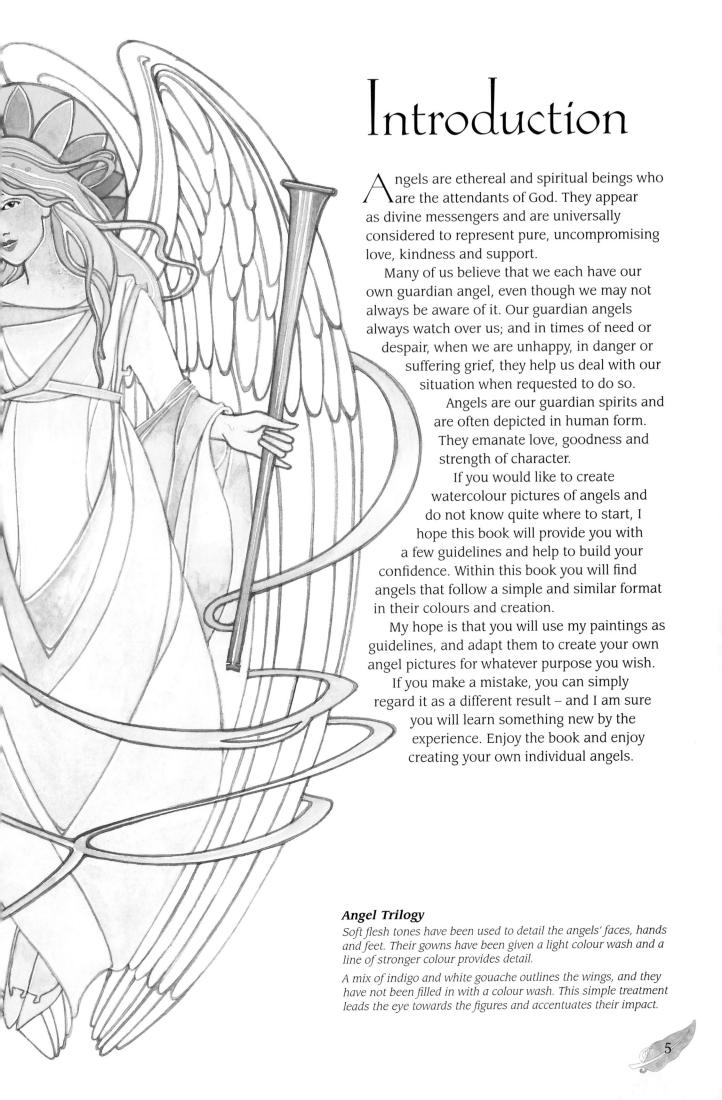

Introduction

A ngels are ethereal and spiritual beings who are the attendants of God. They appear as divine messengers and are universally considered to represent pure, uncompromising love, kindness and support.

Many of us believe that we each have our own guardian angel, even though we may not always be aware of it. Our guardian angels always watch over us; and in times of need or despair, when we are unhappy, in danger or suffering grief, they help us deal with our situation when requested to do so.

Angels are our guardian spirits and are often depicted in human form. They emanate love, goodness and strength of character.

If you would like to create watercolour pictures of angels and do not know quite where to start, I hope this book will provide you with a few guidelines and help to build your confidence. Within this book you will find angels that follow a simple and similar format in their colours and creation.

My hope is that you will use my paintings as guidelines, and adapt them to create your own angel pictures for whatever purpose you wish.

If you make a mistake, you can simply regard it as a different result – and I am sure you will learn something new by the experience. Enjoy the book and enjoy creating your own individual angels.

Angel Trilogy

Soft flesh tones have been used to detail the angels' faces, hands and feet. Their gowns have been given a light colour wash and a line of stronger colour provides detail.

A mix of indigo and white gouache outlines the wings, and they have not been filled in with a colour wash. This simple treatment leads the eye towards the figures and accentuates their impact.

Materials

If you are new to using watercolours, invest in a good quality set of pans and one or two good sable brushes. It is far better to have a small selection of good quality paints that you can add to, rather than a large collection of poor quality paints that will not give you satisfying results.

Gradually build up your collection of materials and with care they will last you many years.

PAINTS

I use Winsor & Newton Cotman or Artists' watercolours because they give a good transparent colour wash. I prefer pans of colour to tubes because I find that tubes tend to dry up; but using pans over tubes is a matter of personal preference. Both will give you a good result, but I find the artists' colour pans give a more intense colour and permanence.

I often use a combination of watercolour and designer gouache – an opaque form of watercolour which gives a solid layer of colour but can also be diluted for small areas of colour wash. Choose a permanent white gouache for outlines and highlights, and a flesh tint gouache for simple flesh tones. You can build up your own skin tone palette with your watercolours as you build your confidence.

Gouache paints are versatile and easy to use. You can mix watercolour with a white gouache to provide versatility. Gouache can be watered down to produce a translucent wash, just like a watercolour, and because they are opaque they also be used undiluted to create a solid, flat and even colour.

BRUSHES

I advocate the use of good quality sable brushes. They may cost more but are well worth it. If you aim to achieve fine detail, you need a good, fine brush and a steady hand. Several well-chosen, good quality brushes are far better than a large selection of inferior quality brushes.

I use Winsor & Newton finest round sable brushes in sizes 0, 00, and 000 for details. They are excellent for creating fine lines and detail, which is difficult to achieve with a poor quality synthetic brush. In my experience it will only lead to frustration! I also use a size 5 round and size 5 flat for background washes. Use the right tools when painting and you will find that you are halfway there. Winsor & Newton's 'Natural Grip' brushes are good and are a less expensive alternative to the larger sable brushes.

Remember that your brush acts as a reservoir for the colour wash; the better the quality of the brush the better your resulting wash will be. After applying your colour, a clean, damp brush can be used to 'pick up' excess colour from your illustration.

SURFACES

PAPER

Choose a good quality watercolour paper: there are various weights and surface finishes available on the market. Your local art supply shop should have a reasonable selection.

With regard to the weight of the paper, try using a medium-weight paper, no lighter than 190gsm (90lb). The heavier the weight, the less distortion you will get when wetting your paper. I like to use a heavy paper, about 535gsm (250lb), with a smooth finish.

You may get confused by the different surface textures available. They range from quite smooth to a coarse and heavy texture and your choice depends on the effect you wish to achieve.

There are two main categories of finish and it is matter of personal preference which you use: A smooth or HP (hot pressed) surface gives a good flat paper used for fine line work and flat colour washes. A NOT or CP (cold pressed) surface will have a slight texture that can enhance the visual qualities of a wash.

Experiment with different surfaces. You may be able to get paper samples but remember that if you wish to work in detail, a smoother surface is preferable.

ART BOARD

This is wonderful to use, as it is stable to work on and forgiving. A good quality watercolour paper is sealed on to a back board which prevents the paper from distorting in use.

Art boards are more expensive than the sheets of paper and can be difficult to obtain but a good art supplier should be able to help and they are definitely worth using when you get more confident.

Like watercolour paper, art boards are available with the option of HP or CP surfaces, and the whiteness of the paper surface varies with the manufacturer.

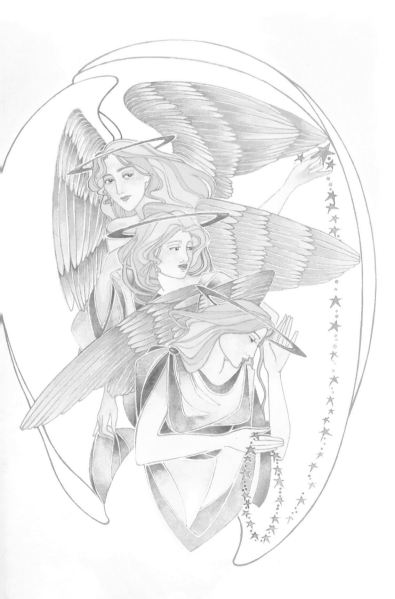

Trilogy
A trio of similar angels has been painted on to a bright white watercolour paper with a smooth surface and 535gsm (250lb) weight. The smoother surface has enabled me to include lots of fine detail on the wings.

OTHER MATERIALS

Palettes These are available in plastic or china. Choose one with divisions forming small reservoirs for mixing small amounts of colour. For mixing larger amounts of paint, be inventive and use egg cups and saucers.

Water pots Choose a variety of small vessels to keep lots of clean water available, otherwise your colours can get muddy.

Pencil and eraser I always have to hand HB, H, and 2H pencils of a good quality and I prefer the cleanliness of a good white plastic eraser.

Pens You may use fineliner pens with black or sepia ink to outline and detail your work, but make sure they are waterproof or the line will run when you apply your colour wash. Choose sizes 0.1, 0.2 and 0.3 to start with. As a general rule, the finer the pen the better.

Masking tape This is useful to hold your painting to your drawing board or to create a 'clean edge' to a painting, but only use a low tack version from your art shop, otherwise you may tear your paper.

Masking fluid This comes in liquid form and is useful to apply to areas of your work you wish to keep white. It has a gum base that can damage brushes, so only apply it with an old brush. When your picture is complete and dry, you can use a clean eraser to gently remove the dried masking fluid.

Soft tissue or kitchen towel This is good for dabbing areas of watercolour to lift out clouds and to soften a colour effect. Don't forget that if your tissue is textured, the pattern can be transferred to your painted surface. For this reason, untextured tissue is better.

Salt Sprinkle salt crystals on to a wet colour wash, let the surface dry then shake the residue crystals away. The salt crystals absorb the colour and create an interesting effect.

Burnishing tool These are available in plastic and have a smooth edge for rubbing down or transferring tracings. The best ones have a smooth polished agate end but are difficult to come by. Use a burnisher by turning your tracing over on to your watercolour paper and rubbing the burnisher over the back of the tracing. Be careful so as not to damage your paper.

Scalpel Scalpels or craft knives are useful tools. A new clean blade can be used to scrape the dried colour surface for effect or to cut out masking tape if you want to protect an area of an illustration. A blade used in its handle provides an excellent tool for sharpening your pencils!

Tracing paper This is useful to sketch details and experiment with composition.

Set square and ruler I like to make sure my paintings are central on the paper and a set square and ruler makes easy work of this.

Cotton buds A clean cotton bud can be used to carefully lift out areas of saturated colour.

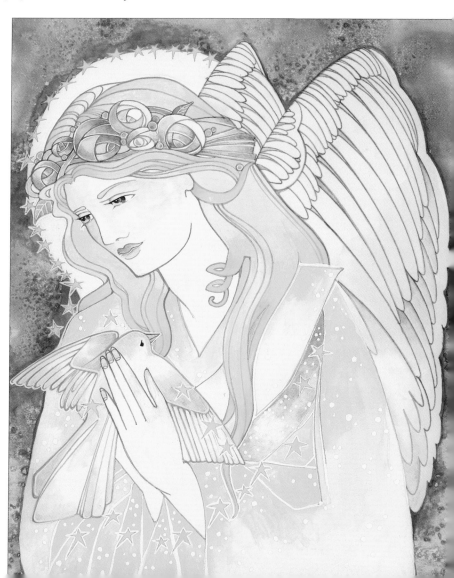

Angel With Dove
The softness of colour on the angel's robes has been achieved by gently dabbing the wet colour with soft tissue. The starlight effect in the background was achieved using salt on the wet paint.

Colours

Build up your own palette of colours over time. The colours I suggest here are intended as a guideline only, and make for a good starter palette.

I prefer to buy an empty watercolour pan case and make my own choice of colour pans with which to fill it. These paints can be mixed to extend your colour range.

WATERCOLOURS

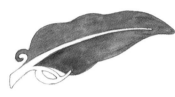

Purple lake

Useful tone for highlighting cheeks, lips and heart details. A pretty colour is produced when this is mixed with white gouache.

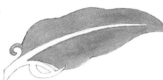

Alizarin crimson

This is a vivid pink tone which is good for highlighting cheeks and detail.

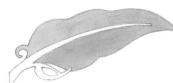

Cadmium orange

A soft orange that blends well with the yellows for the wings and feathers.

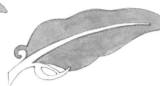

Burnt sienna

Suitable for shading and building depth, this can be used to give contrast in an angel's hair.

Burnt umber

A good all-round colour for shading, especially on hair colours and shading on skin tones.

Yellow ochre

A medium tone that blends well with fair hair colours or for an outline.

Cadmium yellow

A good strong colour for hair, stars, haloes and wings.

Lemon yellow

A soft vibrant yellow, a good colour for atmospheric washes and an effective colour for haloes and glories.

Ultramarine

A good blue for sky washes and angels' robes.

Intense blue

As its name implies, this produces a vivid blue with depth when used as a strong wash.

Cerulean blue

A soft colour, good for clouds and robes.

Viridian

A cool green that tones well with the blues.

Sap green
This is quite an acid green that sits alongside the yellows and golds well.

Indigo
A must-have colour for your palette, indigo can be used to strengthen other colours, detail eyes and as a background wash.

TIP
Indigo can also be mixed with white gouache to give a soft grey outline: another use for this versatile colour.

GOUACHE

White gouache
Solid white permanent gouache can be used for outlining and highlights. Have this to hand, blend it with an intense watercolour, and it will create an opaque and solid body colour. This gives a dense colour effect that will provide a contrast to the soft transparent watercolours.

Gouache flesh tint
Use this in a diluted form as a soft wash for flesh tones. When you feel confident, you can mix your own colour for skin (see pages 16–17).

EXPANDING YOUR PALETTE

The paints already listed provide all the colours you need to paint the projects in this book. Everybody has different tastes, so feel free to experiment with different colours. Here I suggest some good additions to your palette that complement the other colours I use.

Cadmium red deep
A soft red, a good colour for use in skin tones or for flower detail.

Indian red
Soft brown-red hue that is suitable to mix for skin tones and shading areas.

Red ochre
A good colour to wash alongside yellows and golds for hair and drapes.

Brilliant green
A good colour for foliage and an all-round green.

Cobalt blue
A deep, intense blue that is good for skies. Cobalt blue is a very dramatic colour.

Sepia
A good all-round colour for shadow washes and outlines.

Techniques

It is important to give your angel picture a feeling of softness and for the angels to look serene and gentle. Take care when sketching your figures and look at reference material that you may have collected of angel images. Look at their shape, position and stance.

FLAT WASHES

Lay your work flat for an all over or background wash, unless you want one colour to blend with another. If you are covering a large area with colour, make sure you mix enough paint as it is not a good idea to mix more as you go along. Watercolours need to be wet or damp to blend into each application and they dry very quickly.

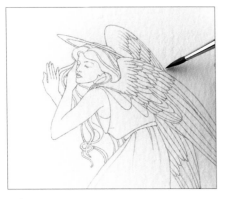

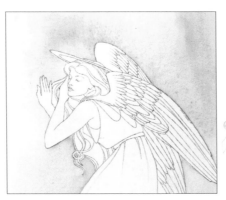

1 Draw your angel with an HB pencil, then wet the area with a size 5 brush, working right up to, but not over, the pencil outline.

2 Carefully lay in a wash of intense blue to the main area you want coloured. It is important to keep the wash thin.

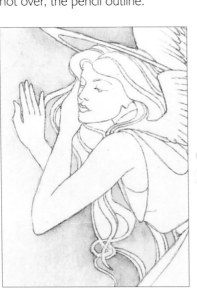

3 Use a size 0 brush to fill in the smaller areas of background such as within the angel's hair and in her halo.

TIP

Shading your angel by overlaying the same mixes wet-on-dry, as shown here, allows you to use pale colours without the finished piece looking washed-out.

4 Once the wash is dry, you can lay in the same mix wet-on-dry around the angel. This creates shading and contrast to give the angel impact.

TIP

Keep your work and working area clean. It is a good idea to cover the area of illustration you are not working on with a sheet of clean paper or lay a piece under your hand to protect the drawing. Keep your hands clean so as not to mark your papers.

TIP

Flat washes can be used for covering large areas with colour, so use a large brush. Small, detailed areas can be painted using a fine brush.

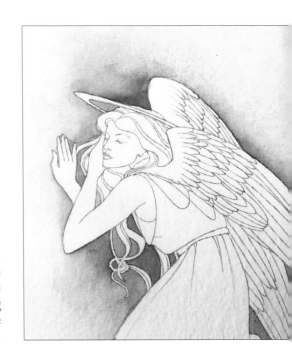

VARIEGATED WASHES

If you are using two or more colours for a variegated wash, make sure all your colours are mixed well before you start. In this case a deep orange blends into yellow for a sunset. This technique is especially effective for backgrounds and landscapes.

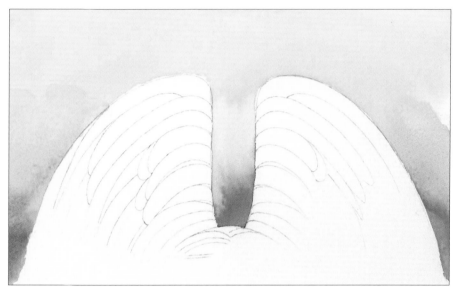

1 Carefully wet the area with a size 5 round brush, then quickly lay in a lemon yellow wash, working from the top down.

2 While the paper is still wet, lay in cadmium orange from the bottom up. The two colours will merge into one another where they meet, creating a soft, variegated wash.

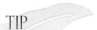

TIP

Make sure you always have plenty of clean water to hand and keep your brushes clean. A damp brush can be used to encourage colours to blend. A dry brush can be used to lift excess colour, like a tiny sponge.

3 You can encourage the colours to bleed into one another with a clean damp brush for an even softer gradient.

OVERLAYING WASHES

Use the following technique when painting the angel's wings or an area that requires shadow. The contrast between the lighter and darker areas helps give form and create impact. Remember to take your time and work cleanly and carefully.

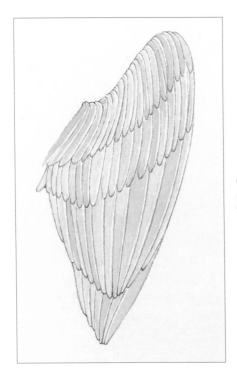

1 Lay flat washes of lemon yellow on to each feather individually to create a natural-looking colour variation on the wing. Leave a thin strip of clean paper at the right-hand border for highlights.

TIP

If you are not confident leaving a border, you can mask the edges with masking fluid before you begin.

2 When dry, blend a stronger cadmium orange mix wet-on-dry where the underfeathers meet the top layer, working from the top of each feather downwards. This will to add a darker tone, contrast slightly and form a shadow, giving a three-dimensional effect.

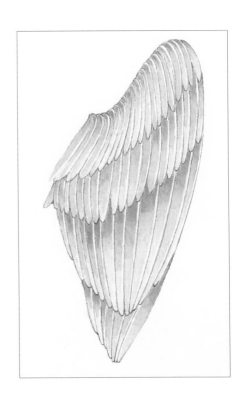

3 Use a size 000 brush to add highlights with white gouache, paying particular attention to the tips of the feathers.

TIP

If you have used masking fluid, use a clean eraser to rub it away before painting the highlights.

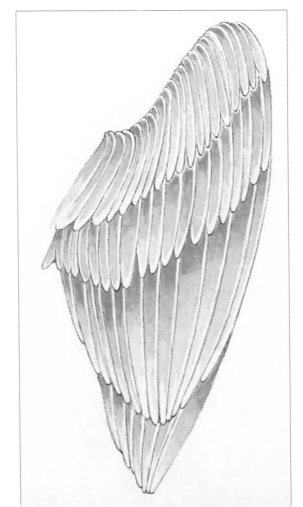

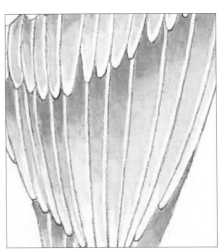

This detail of the wing shows how the shading and highlighting helps to create strong contrast, even though the colours are quite pale. See the wings on Trilogy (page 8) for another example of this technique.

USING MASKING FLUID

Masking fluid can be useful and is quite easy to use. It is effective if you intend to lay a flat colour wash and wish to keep an area or detail white.

Masking fluid is a latex solution that stops paint colouring the paper beneath, so you can paint over the area, and then remove the masking fluid to reveal clean paper beneath. Add a little white gouache if desired to enhance the highlight.

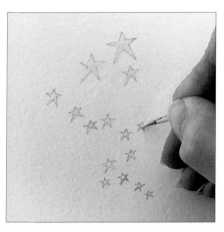 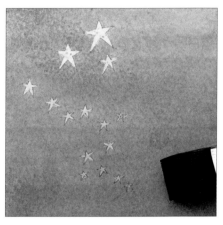 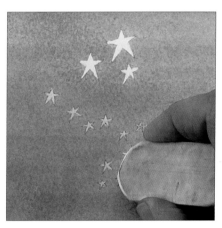

1 Use a cheap or old brush to paint the masking fluid on to the areas you want to keep white, as a good brush will be ruined by the latex solution.

2 When dry, paint a medium wash of purple lake over the area with a size 5 brush and allow to dry.

3 Use an eraser to gently rub the masking fluid off. The area is now ready to paint, or can be left clean and enhanced with white gouache for a highlight.

DABBING AND LIFTING OUT

After laying a colour wash you may wish to soften the edges around a figure or detail. Cover your finger with clean, soft tissue and dab the area you want to treat. This must be done while the wash is wet to achieve the desired effect. Leave to dry before continuing.

TIP
You can get different effects by allowing the paint to dry a little before dabbing or lifting out. The drier the paint, the more subtle the effect.

 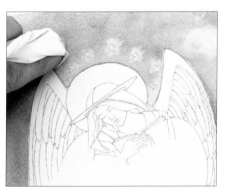 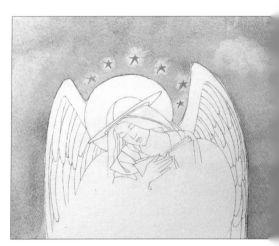

1 Mask out the stars with masking fluid. Once they are dry, lay in a wash of intense blue, then dab a cotton bud on to the masked areas. The cotton bud absorbs some of the wet paint, creating a pale patch around the star.

2 Dab soft tissue on to the background paint to absorb a little of it. This softens the background in patches, giving the impression of clouds.

Here I have rubbed off the masking fluid and painted the stars. Note how the pale patches create an impression of starlight.

SKIN TONES

It is important to keep the skin tones of your angels soft and pale, to give an ethereal feel. Using softer tones than you might use for a human helps to give an other-worldly feel to your angel.

Skin colours are very variable. There are other mixes detailed in the projects on pages 28–35 and 38–45.

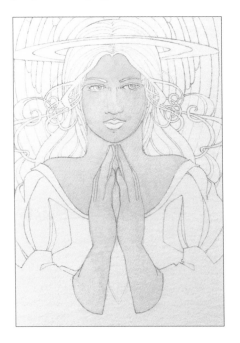

1 Make a mix of flesh tint gouache, white gouache and a touch of burnt sienna. Use a size 0 brush to paint in the areas of exposed skin and dab the nose and cheeks to lift out some of the paint.

2 Add more white gouache to the mix to highlight raised areas on the face such as the bridge of the nose, under the eyes and around the mouth.

TIP

Adding the gouache helps you blend the colours later on and prevents a hard edge from appearing.

3 With a very thin wash of burnt sienna, shade the sides of the face, the neck and around the hands. Build up darker shades by overlaying on to previous shades.

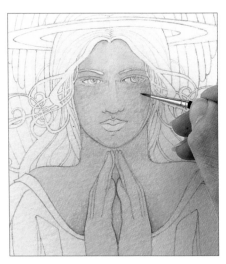

4 With an extremely thin wash of purple lake, add a touch of colour to the cheeks, just below the eyes, and blend the colours with a clean, damp size 00 brush.

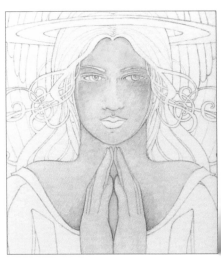

5 Use a wash of white gouache for the final highlights on the face.

Praying For You

The colours are very soft in this picture. A different quality is achieved by blending the colours with white gouache. This gives a creamy and opaque look to the end result.

The skin tones are soft and pure and the whole effect is gentle and calm.

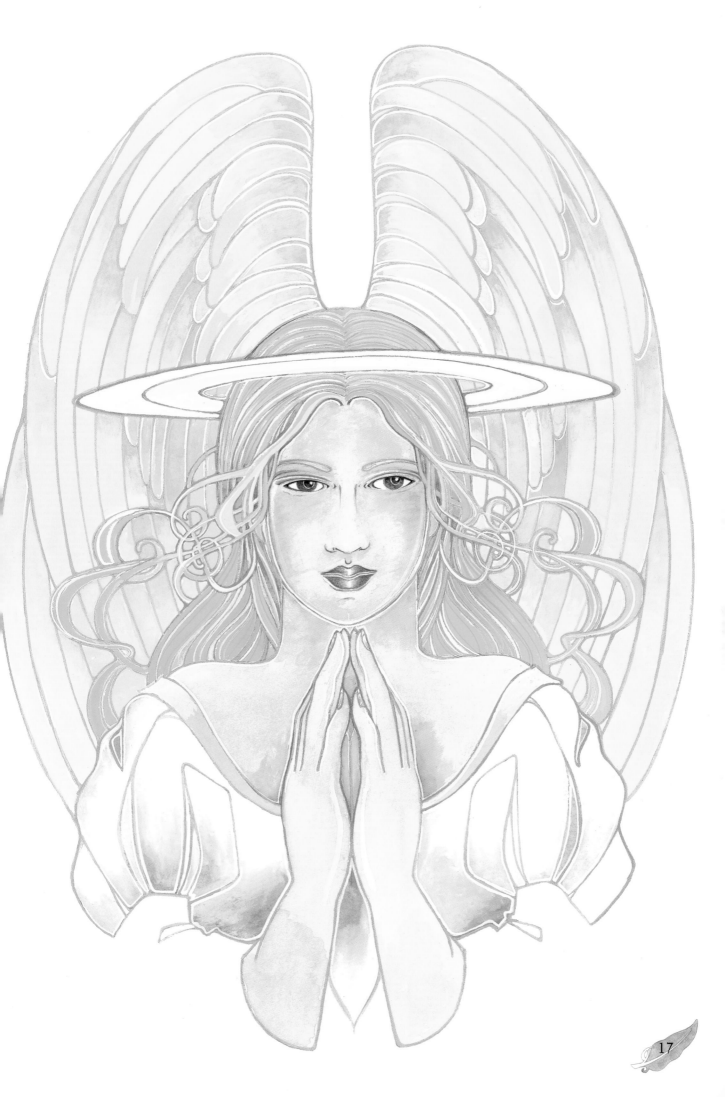

Figures

When drawing angels, I usually start my pictures by thinking of a main subject or detail then I work to develop the layout. I begin by making sketches on tracing paper until I am happy. Rather than using an eraser to make changes to my sketches, I lay a new sheet of tracing paper over the first one and adapt the picture while tracing. You can then discard the part of the image you do not want, and add details to develop the composition. This means that you will never lose any visual information that may come in useful later on.

I often end up with various pieces of a design on tracing paper that I move around and fit together, rather like a jigsaw, before I decide upon my final composition.

TIP

Many artists have used angels in their work. If you find it difficult to decide what form your angel will take, find some pictures or sculptures for reference. Look to see how they have treated their subjects and try not to let your figures look like human forms with wings.

FEMALE ANGELS

To give a slightly less human form to your angel, lengthen the proportions of the limbs slightly, making the distance from hip to knee slightly longer, for example.

Similarly, the fingers, hands and feet can be slightly elongated to achieve this effect. Keep the face slender and try to achieve a serene or gentle expression.

Small wings would look unfitting, so draw the wings quite large and in proportion to the angel's body, as longer lines give an elegant feel.

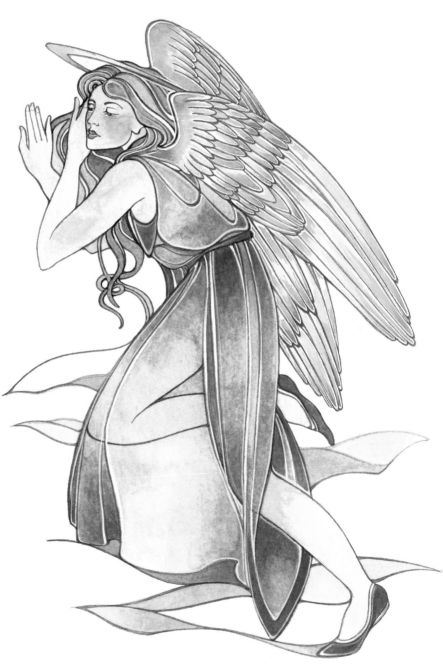

MALE ANGELS

A similar approach can be used for a male angel. Keep proportions long and slender, but avoid an overly heavy, masculine look. He should look stronger than the female angel but in no way threatening.

Facial hair may look inappropriate and softer, longer locks of hair will give male angels a calmer, more serene feel.

TIP

Keep a bit of soft tissue on your finger to dab the colours. This helps soften and blend the edges where two colours meet.

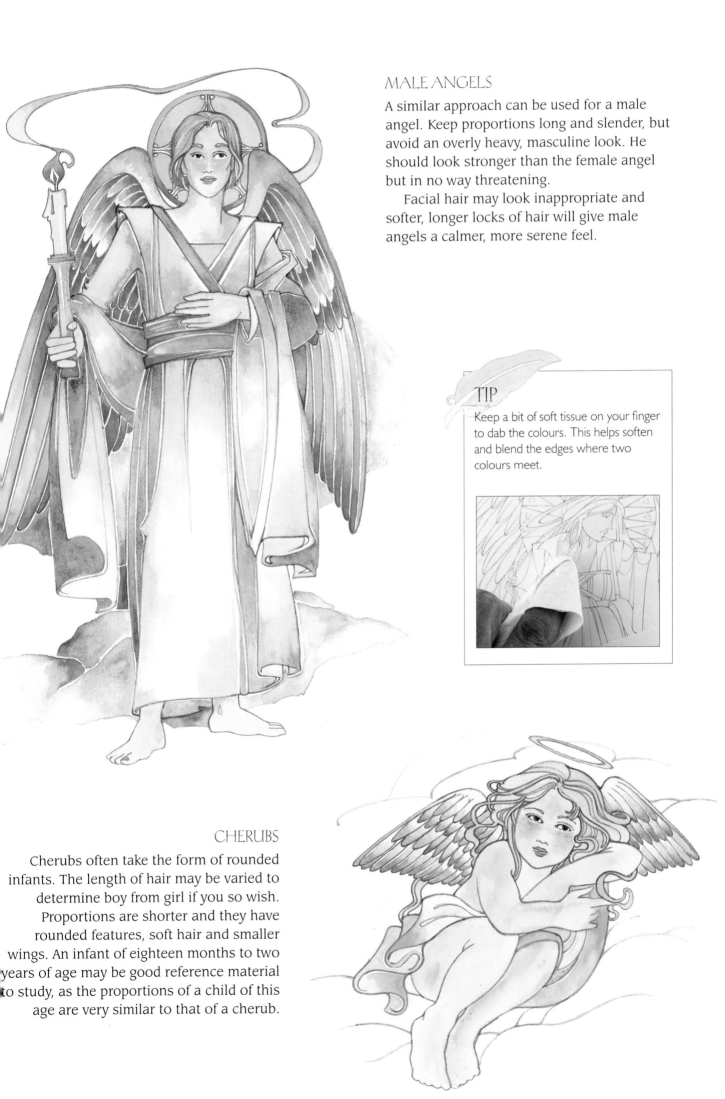

CHERUBS

Cherubs often take the form of rounded infants. The length of hair may be varied to determine boy from girl if you so wish. Proportions are shorter and they have rounded features, soft hair and smaller wings. An infant of eighteen months to two years of age may be good reference material to study, as the proportions of a child of this age are very similar to that of a cherub.

Faces and hair

Many people find drawing faces particularly difficult, so keep the features simple. Angels are usually depicted as being beautiful, with symmetrical features. Gather reference and practise sketching them – the more you do this, the easier it will become.

I follow a simple format: eyes wide and the lids indicated by a fine line. You can give form with shading when you add colour. Keep the lips soft and full.

Hair must follow the shape of the head, so draw the full head before you sketch in the hair. Angels are more often depicted with long flowing locks, and you may enjoy adding this detail. Drawing lines to indicate waves of hair will give you areas to fill in with varying colours and shades later.

TIP
I often omit the vertical line that could indicate the side of the nose when drawing a face from the front, and simply indicate the lower part or nostrils, as shown.

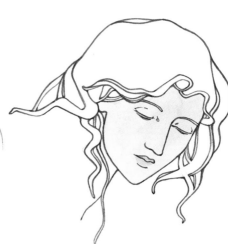

Full face
Angels have soft and almost languid expressions, sometimes with a compassionate or knowing look. Keep the proportions of the face relatively long and oval, with clear details and pleasant features.

The golden-haired and blue-eyed colouring shown above looks very effective when combined with soft rosebud lips.

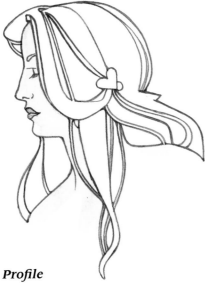

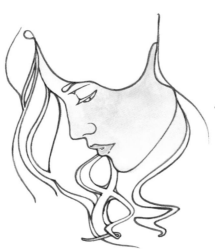

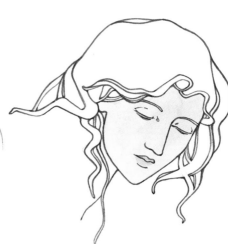

Profile
Looking down or averting the eyes is an appropriate expression. Here the profile appears gentle with a soft hairline and eyelids discreetly lowered.

Bowed head
This position may give a look of piety and could be used for an angel in prayer.

This angel's eyes are lowered but just open, and her hair prettily frames her face and softens her features.

Three-quarter face
This is a good expression to use for an angel peeping over a shoulder, or 'looking on' above a scene. It could also be used to achieve a thoughtful or discreet look.

Halo

A halo can be used to identify your angel, indeed it is an indication that your angel is not human, and emphasises her angelic nature. Most of us associate haloes with the goodness and piety of angels.

Angels are often depicted with haloes around their heads as these two drawings show. Here an elliptical outline gives the impression of a fine ring above the head.

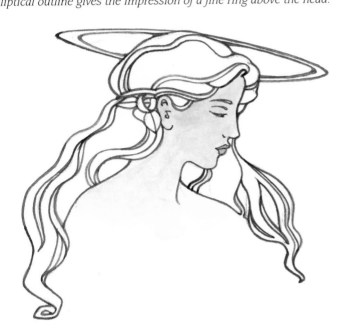

Glory

The glory usually takes the form of a flat circle behind the head, and can be plain or ornate. A glory may be easier to draw than a halo as it always takes the form of a flat circle behind the head, whereas haloes are elliptical.

Use pretty and delicate images like hearts, stars and flowers to decorate your glory, or draw a small pattern and use tracing paper to repeat the design round the glory. If in doubt, keep the decoration simple.

TIP

If you are drawing a symmetrical feature or a design that repeats itself, draw one part and then trace a copy on to tracing paper. You can then simply turn the tracing paper over and rub the tracing into position for a perfect mirror-image copy.

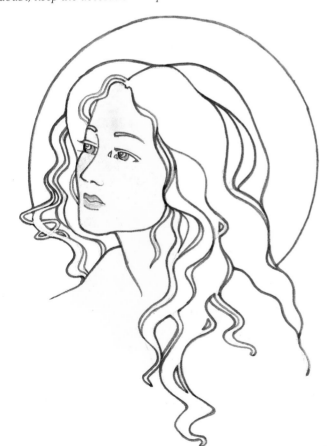

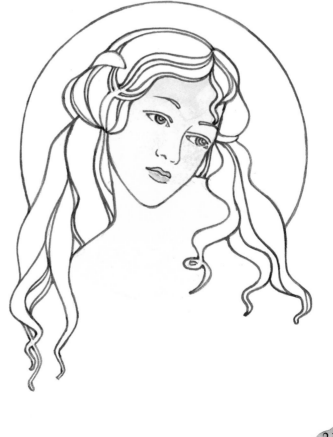

Hands and feet

Like faces, these features can be difficult at first. If you keep them simple, they will soon become easier to draw. If it helps you, use the hands and feet that I have drawn until you become more confident.

Look at paintings and photographs in magazines for reference, and remember to draw what is there when you study hands and feet, and not what you think is there.

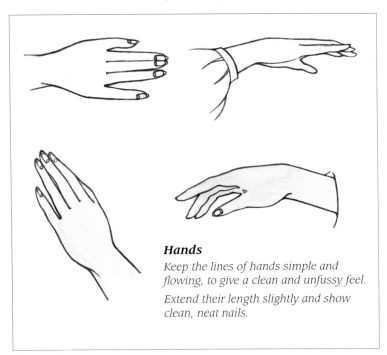

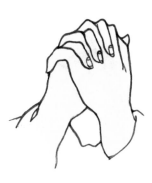

Hands
Keep the lines of hands simple and flowing, to give a clean and unfussy feel.

Extend their length slightly and show clean, neat nails.

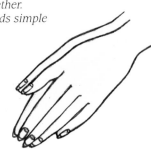

Praying hands
Angels are often depicted praying, their hands clasped or held straight together. Again, keep the hands simple and slender.

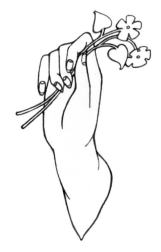

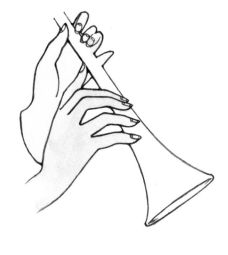

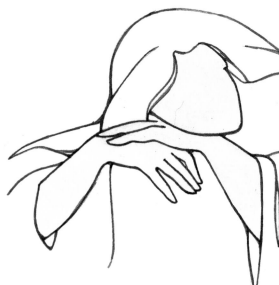

Other suggestions
Holding flowers, playing musical instruments and reclining are suitable alternative poses when drawing angels, and the hands are essential to these actions.

Keep the hands dainty and pretty. Look at the hands of ballerinas and dancers for reference. The hands are used to give a feminine and delicate feel.

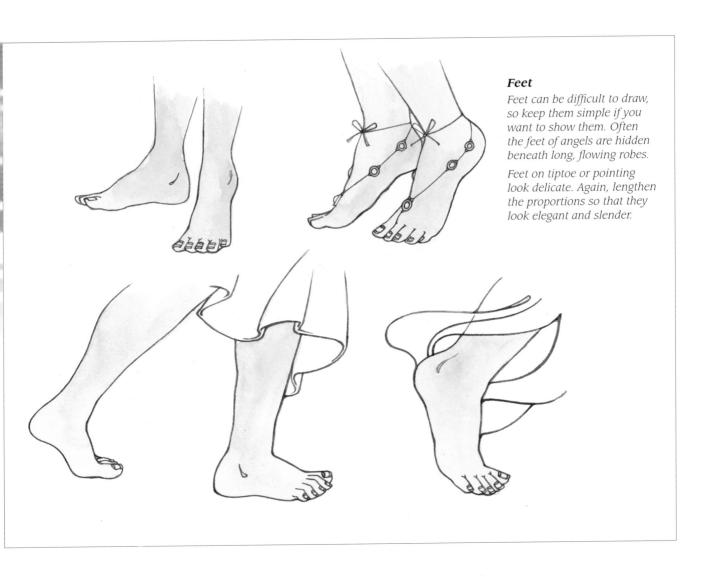

Feet

Feet can be difficult to draw, so keep them simple if you want to show them. Often the feet of angels are hidden beneath long, flowing robes.

Feet on tiptoe or pointing look delicate. Again, lengthen the proportions so that they look elegant and slender.

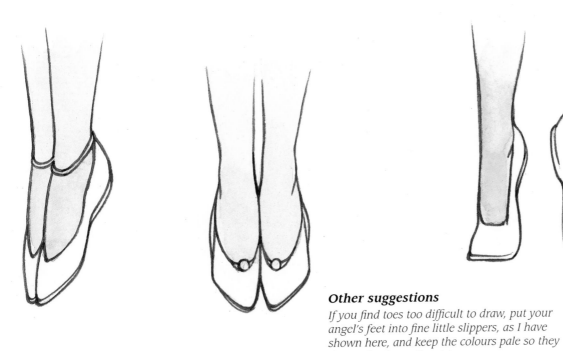

Other suggestions

If you find toes too difficult to draw, put your angel's feet into fine little slippers, as I have shown here, and keep the colours pale so they do not dominate the picture.

Robes

When drawing robes or an angel's clothing it is usual to depict long, flowing lines and softly draped fabrics. Always think of the shape of the angel's body beneath. If it helps, you can sketch the figure first, then dress with the garment. This should help you visualise where to draw the folds.

Remember to let the garments flow and fall gracefully. Study the figures in paintings by artists who depict their subjects in similar attire if it helps, but do keep it simple if in doubt.

TIP
The shape of the body form beneath determines how the clothing falls.

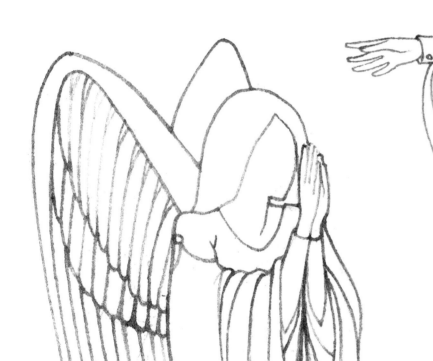

Closed sleeves
Draw the sleeve full and drape the fabric with a detail at the cuff or hand. Fluid, flowing lines help make the robes look soft, adding to the gracefulness of the angel.

Kneeling angel
When drawing an angel in this position, keep the flow of the drapes simple down to the knees, then allow them to loosen and fold over the lower legs and around the feet. Follow the form of the limbs to indicate their shape.

You may like to use the reference for the hands from page 22 and the three-quarter view wings from page 27 to help draw this angel.

You may disguise the feet with the folds of the gown, but remember to include the suggestion of the shape of the feet.

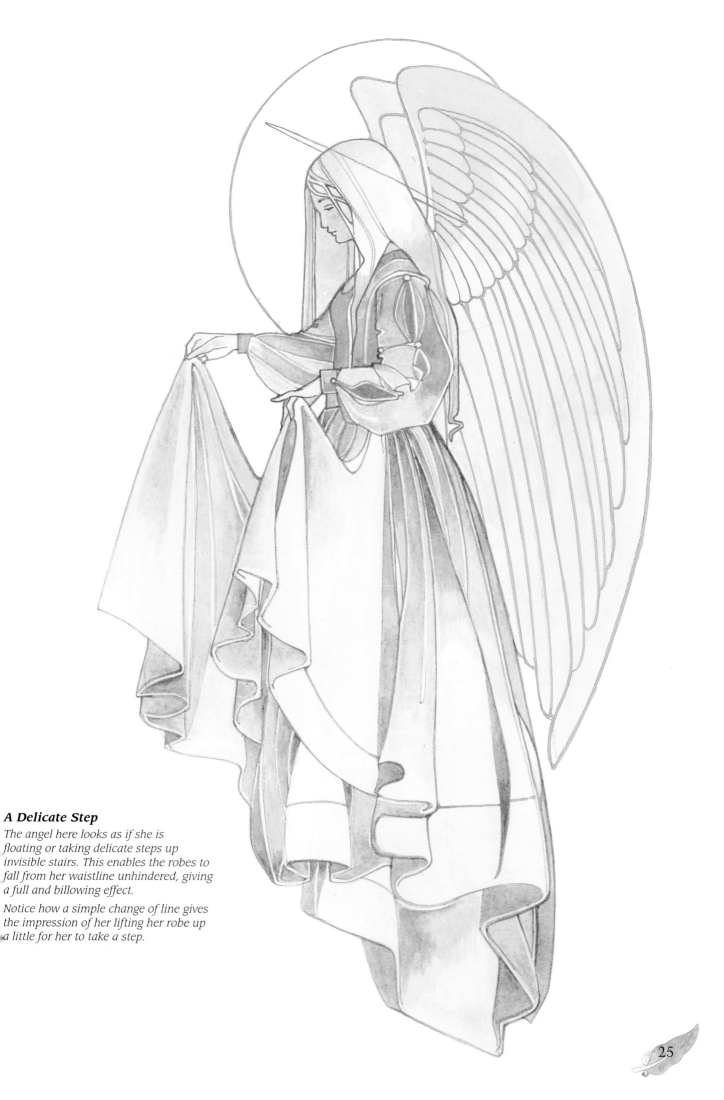

A Delicate Step

The angel here looks as if she is floating or taking delicate steps up invisible stairs. This enables the robes to fall from her waistline unhindered, giving a full and billowing effect.

Notice how a simple change of line gives the impression of her lifting her robe up a little for her to take a step.

Wings

Angels' wings may look similar to those of birds, with shorter feathers at the top near the neck of the angel, then successive layers varying in length. The longer, larger feathers at the tips of the wings give a feeling of strength and weight. Use photographic references of birds to help you draw your angel's wings, remembering that the shorter feathers are nearer the base of the wing where it joins the body. Generally an adult angel will have long and flowing wings.

These drawings suggest how you can depict folded wings when your angel is not in flight.

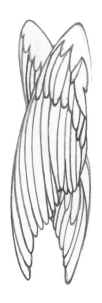

Furled or closed wings, suitable for standing or resting angels.

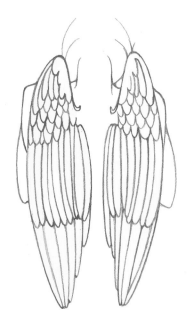

Slightly opened or partially unfurled wings; these are on the point of being extended.

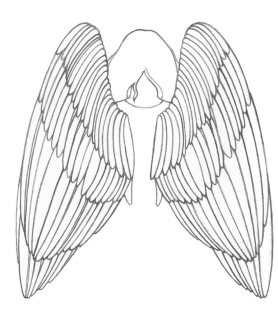

Wings extended and ready for flight, showing orderly rows of feathers.

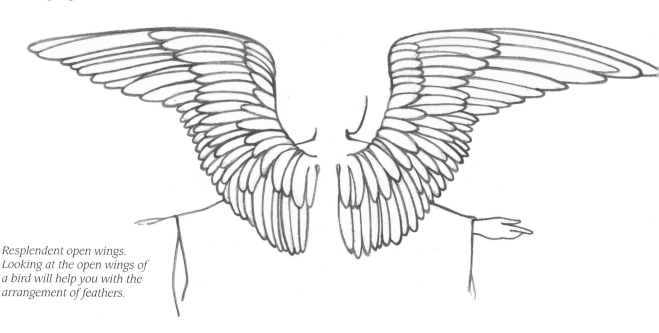

Resplendent open wings. Looking at the open wings of a bird will help you with the arrangement of feathers.

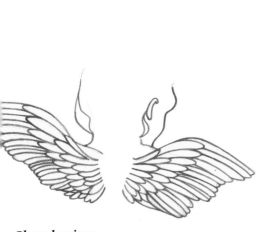

Cherub wings

A cherub's wings tend to be shorter in length than other angels' wings. Often, they almost look as if they are too small to allow the cherub to fly.

Three-quarter view of wings

Because the bottom of the wings will be partially hidden by the figure, you will need to take this into account when drawing them. Most of what you see will be the top part of the wings

Side-on wings

Curve these along the back of the body following the line of the figure.

Draw the wings extended, with the shorter feathers at the top and the longer ones beneath. This will give the impression of length.

The second wing is mostly hidden behind the first from this angle.

Large, open wings

Fully open wings for an angel who means business! This is a very decorative style of angel's wing. You only need to draw one wing, then carefully trace it to make a pair.

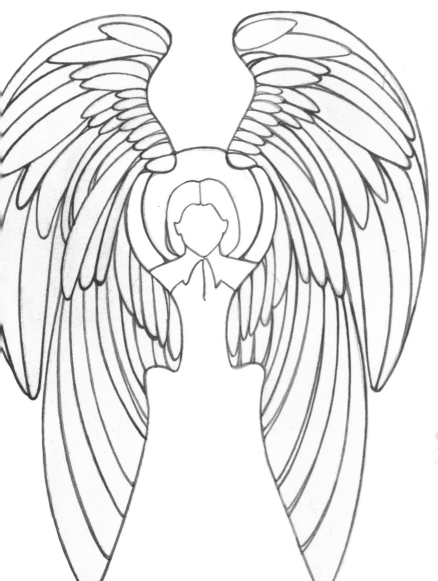

TIP

To achieve a pair of wings that look the same, simply draw one wing following the format shown on these pages. Trace the wing, then flip the tracing paper over, position the image where you want it on your drawing to make a matching pair, and rub down with your burnishing tool. Use an HB pencil, and be careful not to mark your paper by pressing too hard.

Sister Angels

This painting depicts two sister angels who almost mirror each other, joined together with a dove of peace.

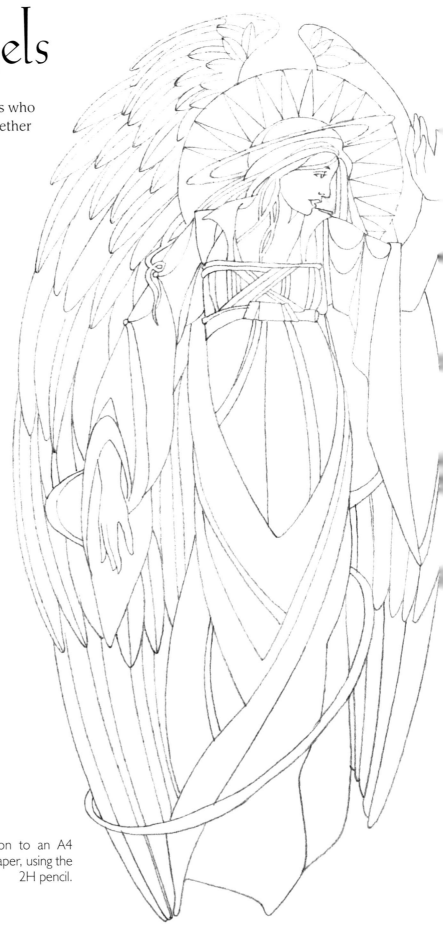

YOU WILL NEED

CS2 NOT Art board,
 380 x 380mm (15 x 15in)
A3 sheet of tracing paper
A4 sheets of tracing paper
Burnishing tool
Paintbrushes:
 size 000 round brush
 size 00 round brush
 size 0 round brush
 size 5 round brush
Watercolour paints:
 Indian red
 cadmium orange
 cadmium yellow
 yellow ochre
 cerulean blue
 viridian
 purple lake
 lemon yellow
 indigo
 burnt umber
Gouache:
 white
2H pencil
HB pencil
Eraser
Masking fluid and brush
Soft tissue

1 Trace the angel on to an A4 sheet of tracing paper, using the 2H pencil.

TIP

You can alter details such as the drapery on the second angel's gown, or keep the angels identical for a symmetrical look.

2 Turn the image over and trace it on to a second sheet of tracing paper, so you have a second angel facing the first.

3 Draw the dove on to a third sheet of tracing paper using the HB pencil.

4 Lay an A3 sheet of tracing paper over both the angels and the dove, and trace the images through with the 2H pencil as shown. Turn the A3 tracing over and reinforce the lines with the HB pencil.

TIP

Test your colours on a spare scrap of watercolour paper first to ensure you have the colour and consistency right.

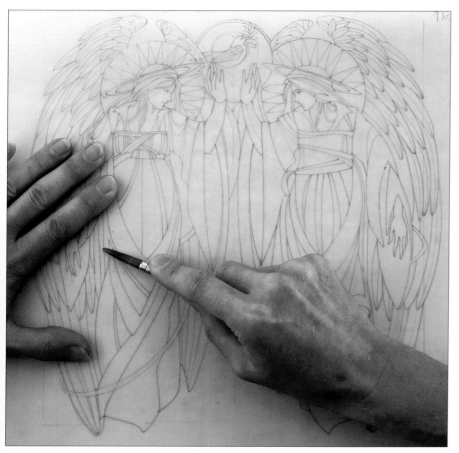

5 Turn the tracing over and lay it on to your art board. Using the burnisher, rub over the whole image to transfer the picture to the watercolour paper.

6 Use the 2H pencil to reinforce and redefine the outlines of the figures, then add the hearts in the glories and hands and on the robes.

7 Using a mix of Indian red, white gouache and cadmium orange, paint the skin of both angels using the size 0 brush.

8 Mask the hearts on both the angels' gowns by painting them with masking fluid. Remember to use an old brush.

9 Add a touch more Indian red and cadmium orange and use this mix to add shading to the skin areas on both angels.

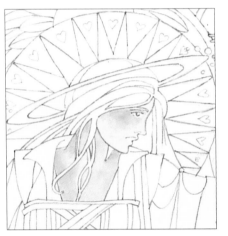

10 Add Indian red to the cheeks and use a clean, wet brush to blend the tones.

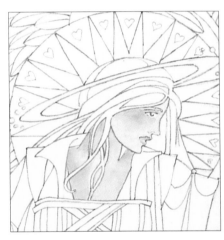

11 Use the same colour to paint the lips, but do not blend the colour in.

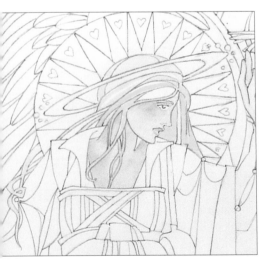

12 Mix a pale wash of cadmium yellow with a touch of cadmium orange, and paint in the angel's hair, leaving some white paper showing through as highlights. Repeat on the other angel.

13 Use a slightly stronger wash to add depth to the colour. Adding a little white gouache will give the colour some opacity. Add yellow ochre to the mix for the darkest shades.

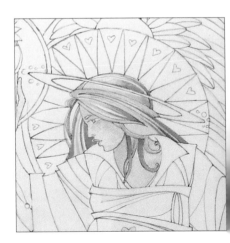

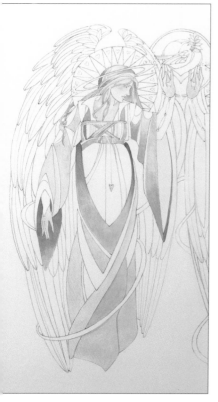

14 With a pale wash of cerulean blue and the size 5 brush, paint the left-hand angel's robes. When areas are dry, overlay stronger washes for shading.

15 Use a pale wash of viridian and the size 0 brush to fill in spaces in the robe.

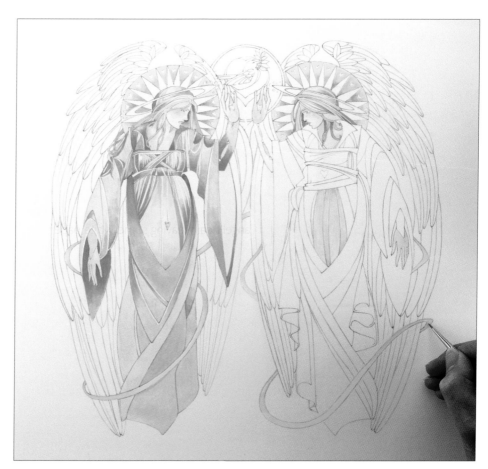

16 Use a mix of cadmium yellow and white gouache to paint the insides of the robes, the ribbons around the angels and the inside of the glories. Blend in pure white gouache for the highlights, and add cadmium orange to the mix for shading.

31

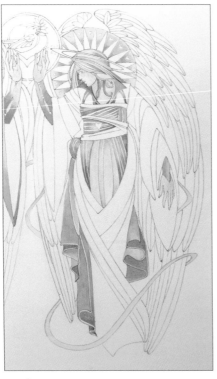

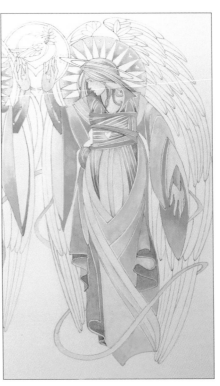

17 Use a thin wash of cerulean blue and the size 0 brush to paint the right-hand angel's robe.

18 Still using the size 0 brush, use a thin wash of viridian to paint the right-hand angel's robe.

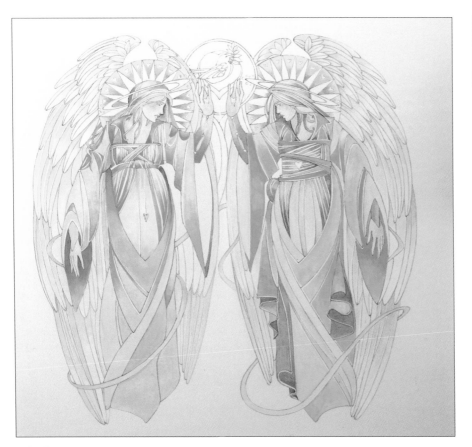

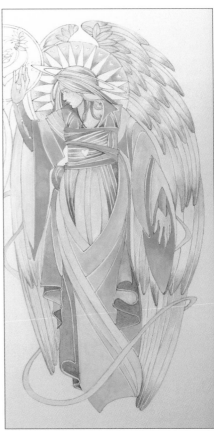

19 Mix white gouache and cadmium yellow. Use this to paint the bases of the feathers, blending to pure white at the tips.

20 Add a tiny touch of purple lake to the wash to give a pink tinge to the feathers.

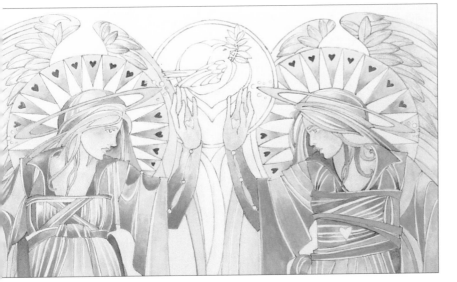

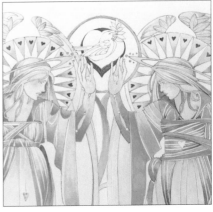

21 Paint the haloes with lemon yellow and highlight by blending white gouache into the wash. Use a purple lake and white gouache mix to paint the hearts in the glories.

22 Use cadmium yellow to paint the central ribbons, the outer ring around the dove and the dots by the haloes, blending white gouache to highlight.

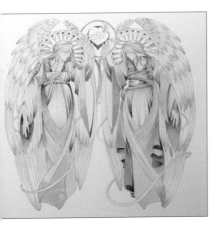

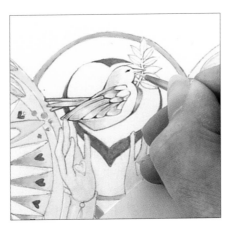

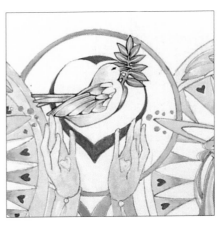

23 Use the size 00 brush and indigo to shade the deeper areas in the robes. Use the 5 brush for larger sections.

24 Paint the dove with the size 0 brush and white gouache. Shade the feathers with indigo. Paint the beak cadmium yellow using the size 00 brush.

25 Paint the branch with viridian and the size 00 brush, then add shading with a stronger viridian wash.

TIP

Indigo is a very useful colour for shading, as it can be used for grey, blue and green areas.

26 With white gouache, cadmium yellow and the size 0 brush, paint in the ring around the dove, then fill in the shape behind with white gouache. Work wet-in-wet and blend purple lake in to the shape.

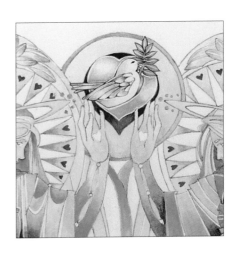

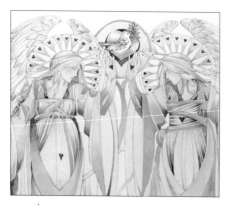

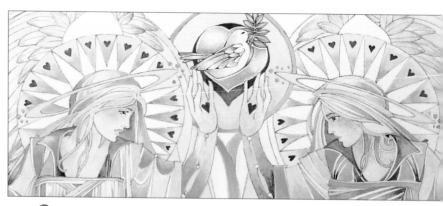

27 Darken the heart shape behind the dove and paint the hearts in the hands and robes using purple lake.

28 Add Indian red to the skin mix and strengthen the outlines of the faces. Use the size 00 brush to re-establish the highlights with white gouache. Use yellow ochre to paint in the eyebrows, and indigo around the eyes. Finally, touch in the irises with cerulean blue.

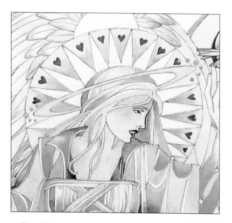

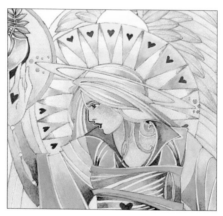

29 Touch in the lips with purple lake, then use indigo to suggest the nostrils and reinforce the outline of the face.

30 Use cadmium yellow and white gouache to paint the rays of the glory, then fill in the spaces with white gouache. Blend this to pure purple lake at the ends.

31 Add defining lines of burnt umber with the size 00 brush to add impact.

32 Use the size 000 brush to paint in the final highlights wit a fairly strong mix of white gouache.

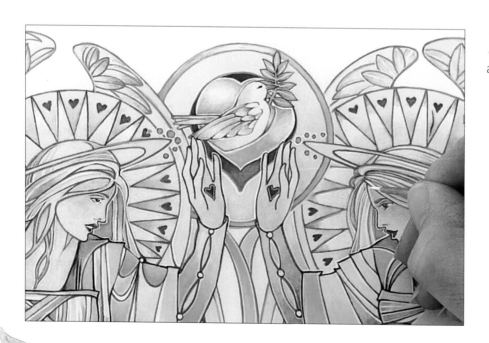

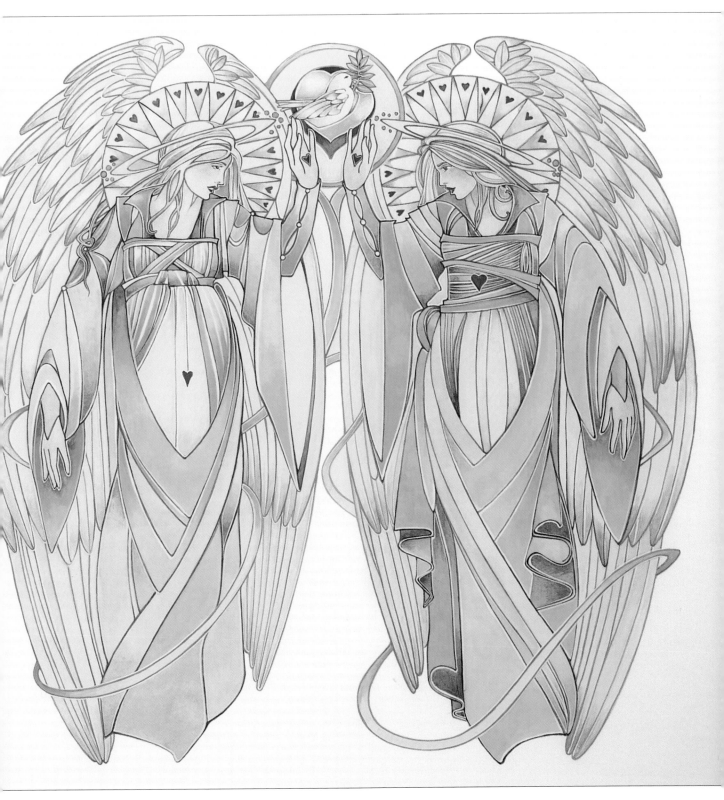

Sister Angels

This painting is a good example of my tracing paper technique. The shape of the angel on the right has been taken directly from the one on the left, but details such as the face, hair and robes have been changed to make her individual.

The glory, hands and wings remain the same and reinforce the idea that the angels are sisters, while the background has been left plain so as not to detract from the impact of the figures themselves.

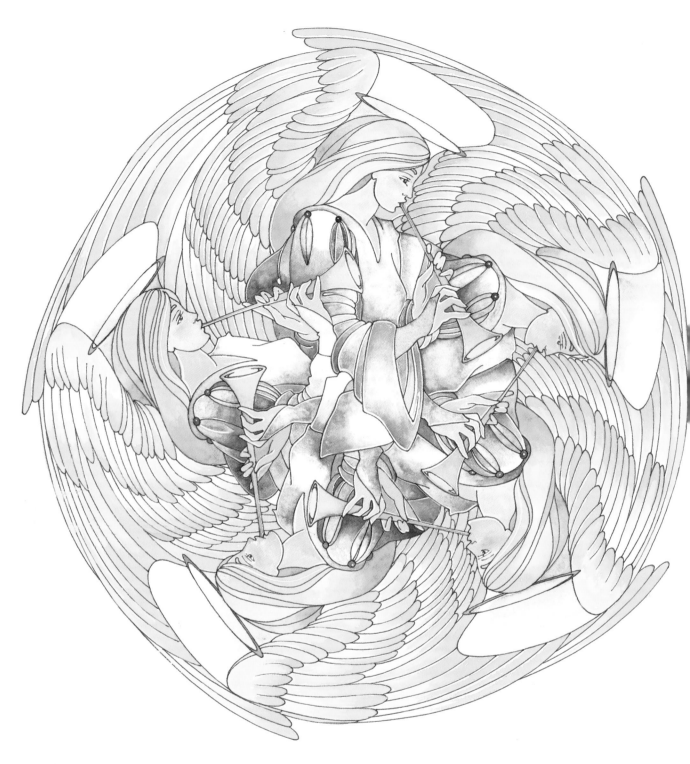

Continuum

In this painting one image of an angel has been repeated to form a complete picture, reminiscent of a stained glass window. The repeated use of the same image results in an interesting finished piece.

Opposite
Sweet Song
Soft watercolour hues combine to give a
angelic atmosphere. This angel has a halo
and a decorated glory. A ruler and set square
have been used to give a border which
outlines a block of colour wash

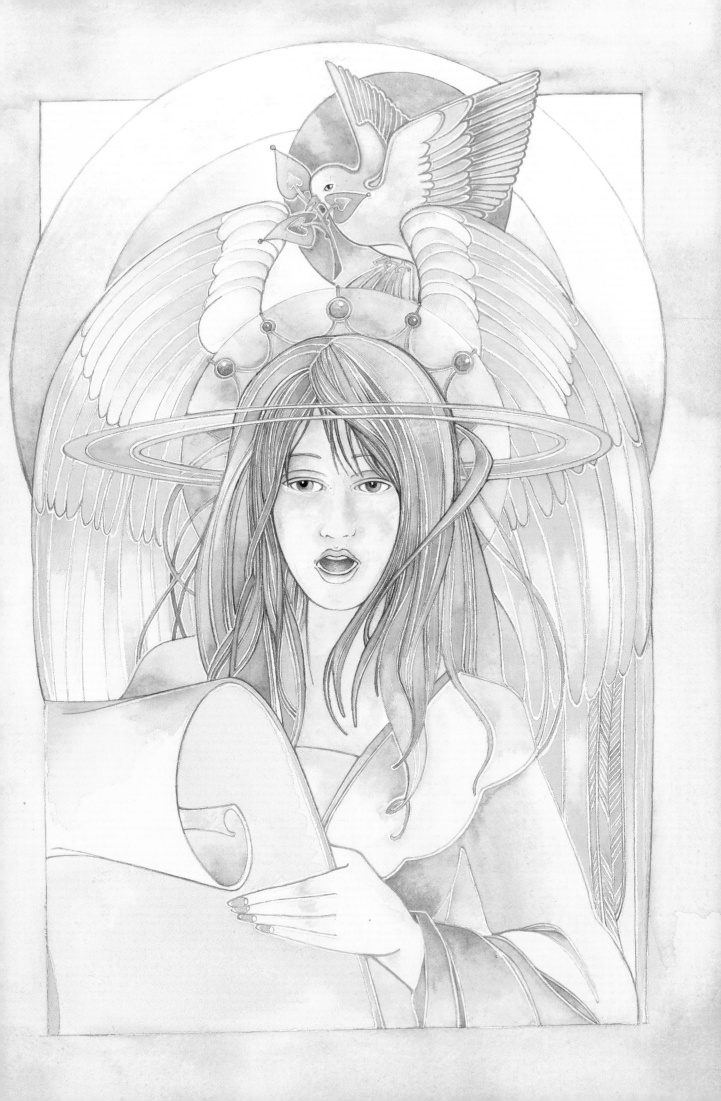

Angel of the Lilies

Angels have long been associated with flowers, especially lilies, as both represent purity and serenity. In this painting I sketched ideas for the composition on layers of tracing paper before I decided on the finished result.

Most of the angel's body is covered by huge wings, and the eye is drawn to the detail on her face, the flowers and wings.

1 Trace the picture using the 2H pencil on a sheet of A4 tracing paper.

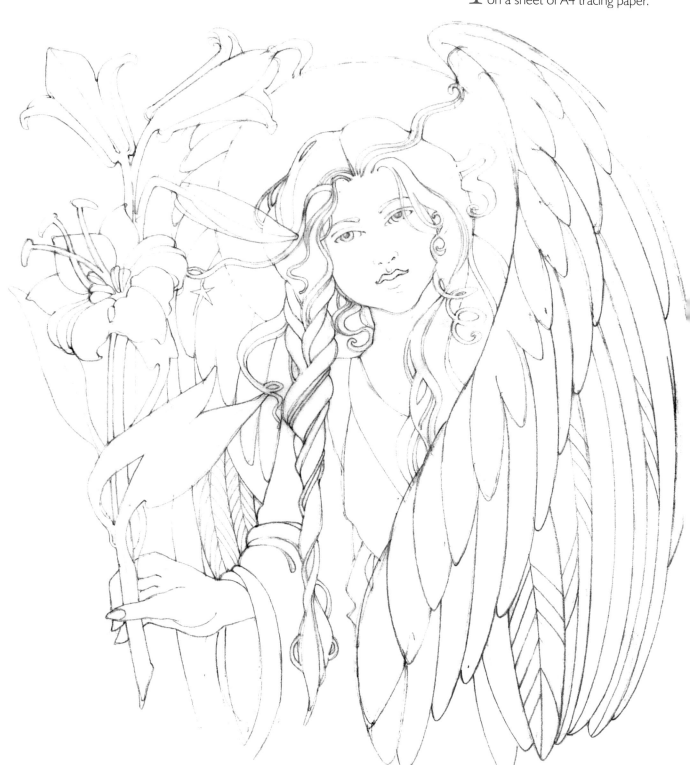

2 Turn the paper over and trace the reverse with the HB pencil.

3 Turn the tracing over on to the art board and use the burnishing tool to transfer the picture.

4 Make a dilute wash of sap green and paint in the stems of the flowers with the size 5 brush.

5 Make a mix of Indian red, cadmium yellow and white gouache. Wash in the skin using the size 5 brush, and overlay a stronger wash in the areas of shadow. Use masking fluid to mask out the stars on the wings.

TIP

Remember to use an old brush when applying masking fluid, as it will quickly ruin your best brushes.

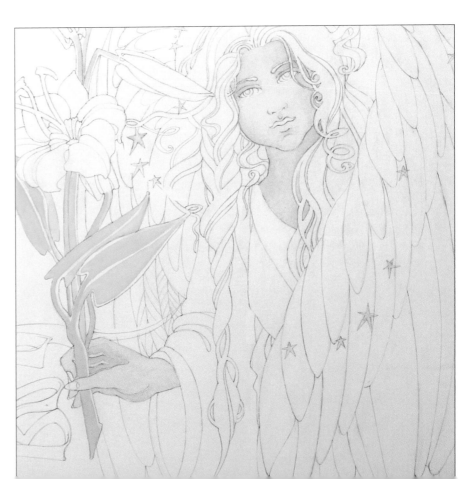

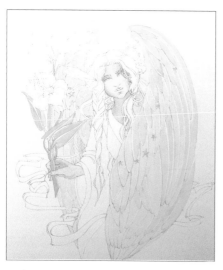

6 Paint a lemon yellow and white gouache mix on the wings, still using the size 5 brush.

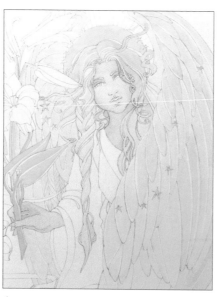

7 Use a thin wash of cadmium orange for the inner section of the glory and the hair.

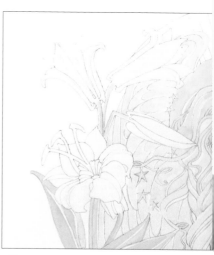

8 Use the size 0 brush with white gouache to paint the flower petals.

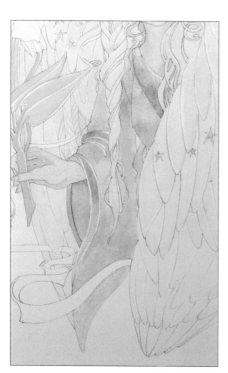

9 Paint the robe with purple lake, working intense blue in wet-in-wet where the shadows fall.

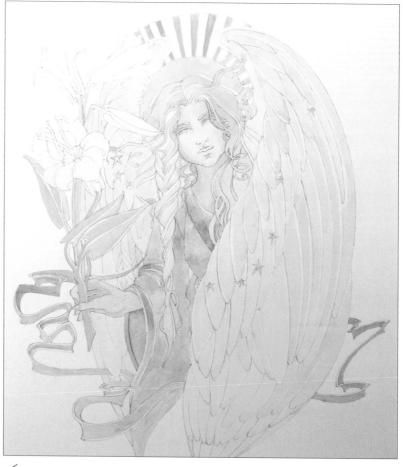

10 Use a cadmium orange wash to paint in the ribbon and every other ray on the glory.

11 Use the size 00 brush and Indian red to paint the angel's cheeks, blending them into the rest of the face. Mix in white gouache to highlight the cheeks.

12 Use a slightly stronger cadmium orange wash with the size 00 brush to paint in the eyebrows. Use indigo to outline the eyes and pupils, then intense blue for the irises.

13 Paint the lips with a wash of alizarin crimson. Once dry, dot in highlights with white gouache.

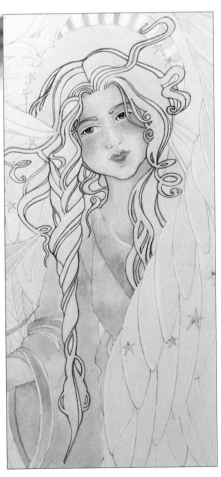

14 Shade and define the hair using the size 0 brush and thin washes of burnt umber to overlay the cadmium orange.

15 Darken the robe with stronger shades of the original colours. Leave some areas unshaded to provide the highlights and texture.

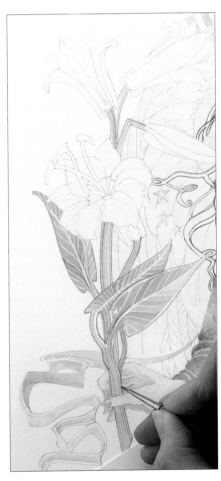

16 Use a stronger wash of sap green for the texture of the leaves and shading on the stems.

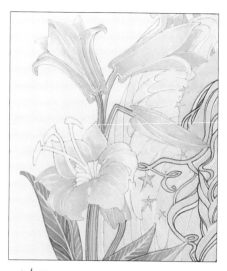

17 Build up the colours on the lilies using the size 00 brush and cadmium yellow, using a stronger wash in the recesses and base of the flower.

18 Outline the flowerheads with a mix of yellow ochre and cadmium yellow.

19 Paint the centre of the open flower with cadmium orange. Outline the details with a strong mix of yellow ochre and cadmium orange.

20 Use the same mix and brush to shade the glory, then define and shade the wings using the size 00 brush with a mix of cadmium yellow and yellow ochre.

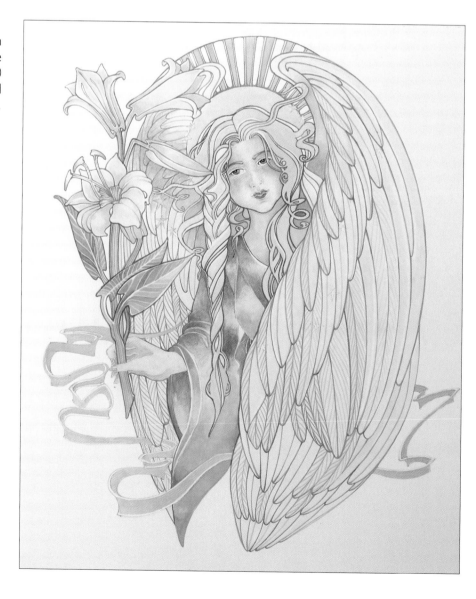

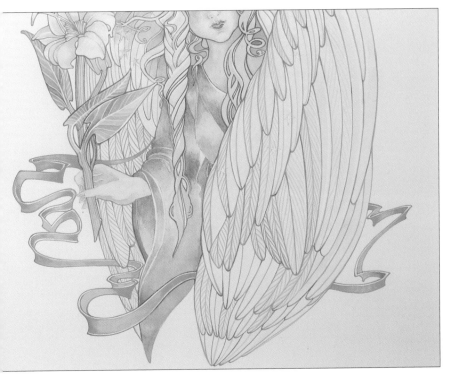

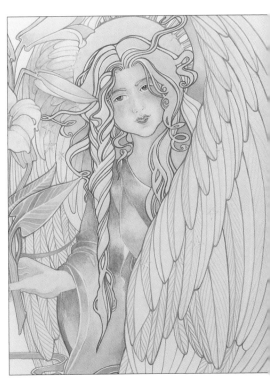

21 Still using the yellow ochre and cadmium orange mix with the size 00 brush, shade and detail the ribbon.

22 Switch to the size 0 brush and add shading to the angel's hair using a mix of yellow ochre and Indian red.

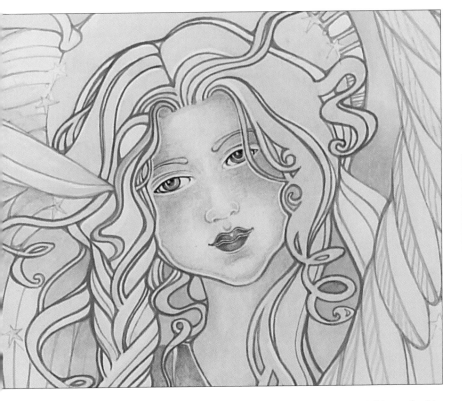

23 Line the eyes with an indigo and white gouache mix. The addition of white gouache gives the colour intensity. Use the same mix for a subtle eye shadow, then darken the lips with an indigo and alizarin crimson mix.

24 Still using the size 0 brush and the indigo and alizarin crimson mix, shade and warm the neck and hand. Use yellow ochre to define the edges of the hand.

25 Use indigo to shade and define the folds in the robe.

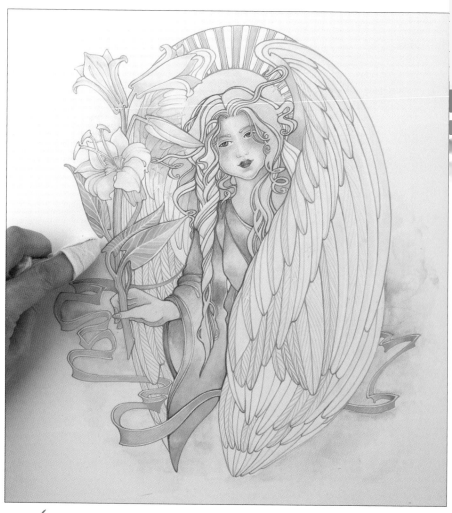

26 Lay in a thin wash of ultramarine on the background with the size 5 brush, and dab the area with soft tissue to lift out clouds. Use the size 0 brush and a cotton bud to lift out the small areas enclosed by the ribbon.

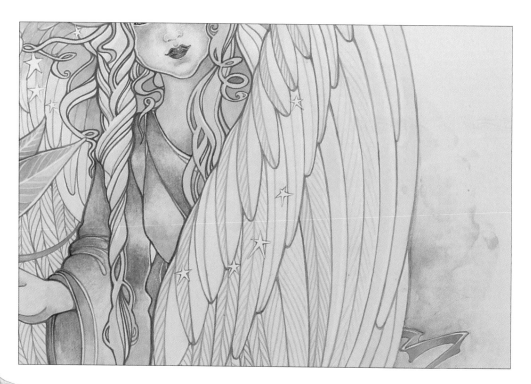

27 Rub the masking fluid from the stars on the angel's wing, and paint them with white gouache.

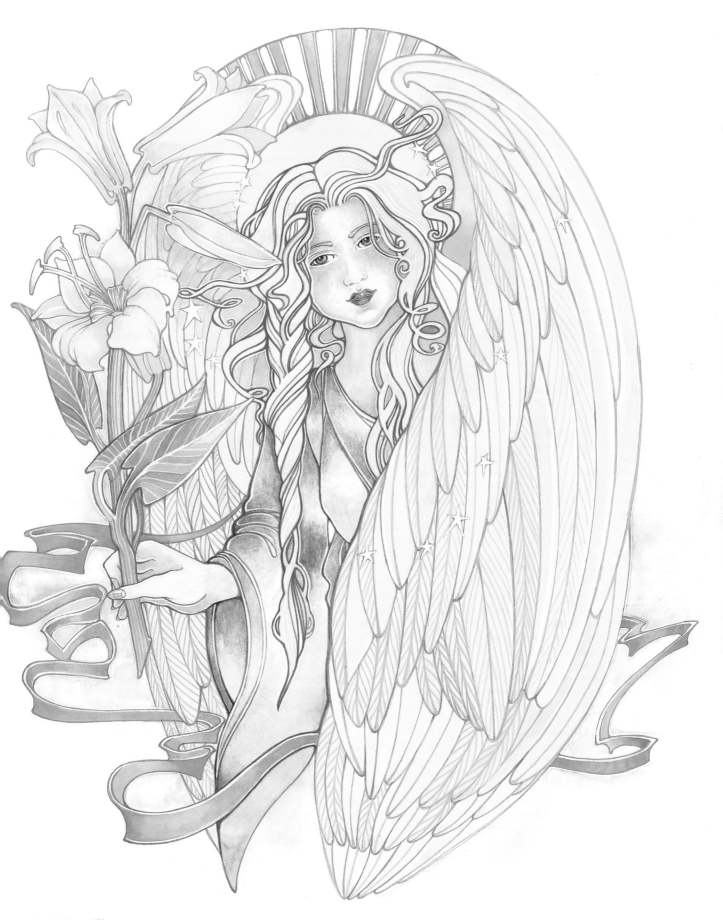

Angel of the Lilies

My intention for this painting was for the subject to appear the epitome of what I regard an angel to look like. Gentle, loving and discreet – 'she will come if you call her'.

The lilies symbolise her purity, beauty and absolute loyalty. Using similar colours for the flowers and her wings gives unity to the picture as a whole.

45

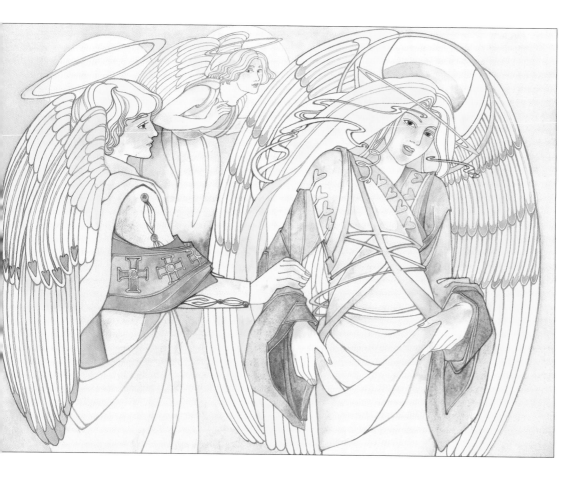

Gentle Support

Soft colours of a similar tone to Angel of the Lilies *have been used for this painting, giving a light and bright atmosphere. Simple lines define the fabric drapes and the whole picture has a more stylised approach, which in turn gives the composition a more two-dimensional effect.*

The main elements are the outlines in stronger mixes of the washes, and a soft wash in a complementary colour for the background.

Adoration

The same techniques as in Gentle Support *and* Angel of the Lilies *were used, but with stronger colour tones. Coloured outlines define the linear quality without losing the necessary softness. Pale blues dominate the colour palette and the variation of tone gives the wings form and a more three-dimensional effect.*

The hair of the angel in the foreground has been painted with a mixture of soft golden yellows to add depth.

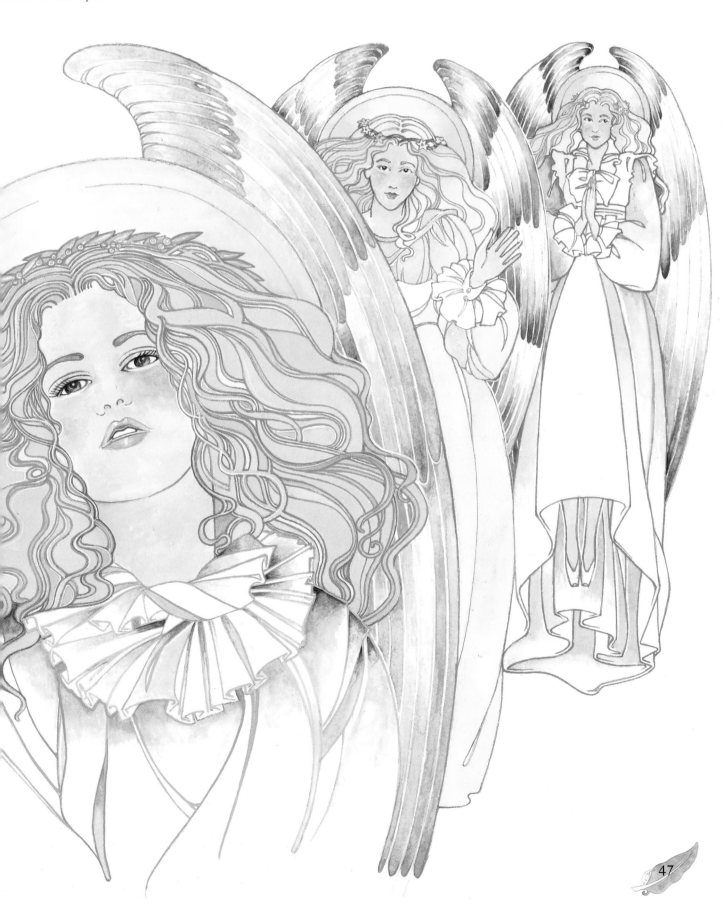

Index

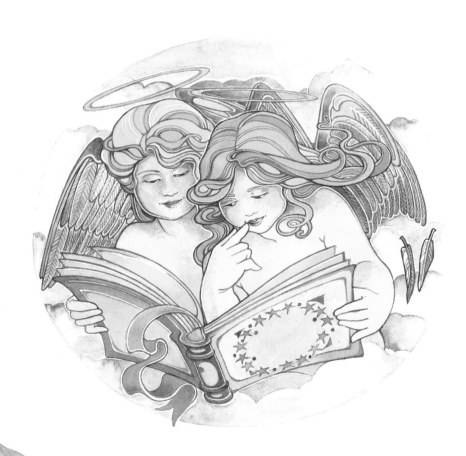

Sharing

The cherubs follow a similar format as used previously, with a soft colour wash on the flesh tones and varying yellow tones in the cherubs' hair.

Layer washes of the same colours to build up depth, allowing them to dry in between each application. Use white gouache for the highlights. Keep a light and bright atmosphere to reflect the nature of the cherubs.